T0129504

Harriet's Journal

Harriet's Journal

Written by
Michael Springthorpe

authorHOUSE®

AuthorHouse™
1663 Liberty Drive
Bloomington, IN 47403
www.authorhouse.com
Phone: 1-800-839-8640

Published by AuthorHouse 01/19/2012

ISBN: 978-1-4634-4438-9 (sc)
ISBN: 978-1-4634-4439-6 (e)

Library of Congress Control Number: 2012903842

Email: michaelkategs@yahoo.com

For Kate, Betsy and Robin

. . . and for all those beloved ones spoken of herein.

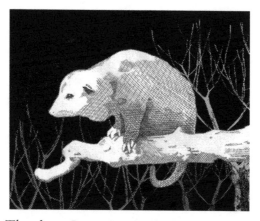

Thanks to Betsy Arcari, (stairway image),
Cindy Hernandez (back cover photo)
and
Shane Wapskineh (black and white image).

Harriet first began keeping a journal when she was six months old. She didn't write anything down—writing is not easy for possums, especially babies, but she kept everything in her mind. She lived with her mother and siblings in a big oak tree in an area that Don, the grey dove, told her was called "Toloo kalake". Don knew many things but she didn't get to see him as much as she would like because, being a possum, she mostly hung out at night when most of the birds were asleep and there were mainly cats, who were nasty, and sometimes dogs—who just wanted to chase a possum on sight! She didn't like her five siblings much, they were loud and noisy especially the eldest one, Reould,

who told her she had a big nose. She loved her mother, who wore herself thin running about keeping her eye on all the babies and teaching them, but her father was a dark and distant figure. Sometimes she would see him several trees away, laying along a branch and gazing sullenly, but he would never even acknowledge her wave. She loved Prilty, a tiny possum from the fir tree on the other side of the grassy field, who was actually a couple of days older than Harriet but who seemed always like a little sister. She was very good at getting those little green kernels out of the centers of the nut-flowers on oak tree saplings. She would just stick her littlest finger into the edge between the kernel and the cob, twist, and out they popped—ready to eat. She tried to show Harriet how to do it but every time she tried the kernel broke

into a myriad of tiny, slimy pieces and the two friends would laugh so much.

An old, big house that's windows were boarded up was at the back of the big field. Those strange, weird, vertical "humuns" who never climbed trees or flew but hung out on the ground all the time and went about in big, noisy "carzzz", as Don called them—some of those had lived there but they had died long before Harriet was born, and now just a single man~humun lived on the grass field in a big box with wheels.

One day, in the Change of Colors time, when the sugar is full in the green leaves and they turn to many different reds and golds and browns, Prilty told her about a great feasting that would take place at chestnut and sycamore trees in the gardens of a human~house on the other side of the

black strip. That was the place beyond the walls and gates of their green field, where the "human cars" whizzed by day and night and where they had never been allowed, and in fact had never dared to go before. But Prilty was adamant. They were getting older, they were almost full-grown and it was time they explored some things on their own without having their mothers nearby. And there was one other thing that Prilty was excited to tell her—at the Feasting there would be boys! Harriet thought that Prilty was a bit too concerned about boys. She would always point one or another out to her and say "He's nice" or "He's quite good-looking" but whenever they came near she would say "Hi Scrawny!", "Hi Jerk-Face!"—but Harriet knew she was interested. As for Harriet she didn't much

care for them—those that she knew like her brothers and others that she'd seen, seemed rather stupid—always rolling around and punching one another, they couldn't sit still for a minute. She knew her mother would never agree to her going but Prilty said they would only be gone a short while and nobody would miss them. She didn't know, she worried about it and she was terrified of the black strip. But yet the idea of going to the Feast, the more she thought about it as the time came nearer, the more it seemed strangely interesting to her.

Soon the day in question, or rather the night, came. Prilty waited at the bottom of Harriet's tree. It was quite dark now and all of the others had gone out to forage. Harriet had pretended she was still asleep when the others left, she felt a bit sneaky

about that but still, she reassured herself, the two of them would only be gone a short while. She clambered down to meet her little friend and together the two ambled off down the gravel driveway towards the big gates. They squeezed through them, that was easy but suddenly they were beyond the walls of the field for the first time. Harriet felt her heart pounding and she took some short breaths, Prilty touched her arm and gave a reassuring smile. They walked across the grass verge and then the white gravel part and now the Black Strip was before them. Harriet said "Perhaps we should go back", but Prilty said "Don't worry. There it is!" She pointed to a big white stone house behind black gates just across and down from where they were. There were no cars about, the black strip was quiet and still.

"It's easy, watch," said Prilty, and off she bounded across the black strip to the safety of the white gravel on the other side. She turned and waved then gave a two-fisted arms-raised signal as though to say, "Yah, I did it!" Now it was Harriet's turn, she took a deep breath—no cars about—and Prilty called her! Or did she call her? Did she say "stop"? Her voice was faint that far away and the noise made it harder to hear. She was on the black strip now but Prilty was waving and saying "No!" "Why 'no'?!" "Go back!!" screamed Prilty—the noise before was a "carz" noise from way down the black strip. Suddenly the noise was so loud and white light flooded the black strip around her—then a terrible high squealing sound began—she sat bolt upright and saw but couldn't hear Prilty's anguish.

Then a great heavy shadow was above Harriet—a terrible iron-heavy shadow and before the next moment of time had passed she felt as though her head had been broken apart. Her scream of agony was choked by a throatful of her precious blood—light fractured in her and a deep, dark water of nausea filled her up. Pain like slabs of burning matter fell through her, through her neck, through her shoulders and all down through her body, and greasy, fat globs of blood flopped onto her hands from her nose shredded inside. Then numbness came—like everything had gone hard inside her. She felt as though she was beginning to fall—not to the ground but into herself. Deeper and deeper she fell, further and further—a fall without end into black unconsciousness.

Suddenly there were legs around her,

human legs, like a cage around her—voices and shouts and screaming sounds and all the while the dark, heavy shapes whizzed by spraying light. Dear Prilty, was she hit too? She was across the black strip though. Still the blood bubbled out of her nose, she pawed at it but oh it hurt so much she couldn't bear to touch it. Suddenly she felt swirled around and she was falling, no—skidding, no—backwards—on all fours—her head rocked with horrible new pain, her claws tried to grip but couldn't—her tail was being pulled, pulled! She was off the black strip on green grass. She ran blindly a few steps and collapsed in deeper grass. She spewed up blood. She spread-eagled on the ground as though the earth and grass would draw from her all her bilious agony. How long she lay there she didn't know.

The next thing she became aware of she was lying on something cold and hard and with bars around it. And she was inside something—some big room with windows and with humans in front of her—and then the room started to move and she realized it must be a "carrz" they were in. But it wasn't bumpy and loud—as they rolled along this one was smooth, and as soft as her mother's touch.

Her head felt like a giant, burning heavy thing and it quaked with her heart's beating. She felt dizzy when she moved her eyes and the sickness melted through her when the dizziness came. Blood, like a slow worm, came from her nose and on her lips it was a sickly sheen—with her thickened wad of tongue she could feel it and taste it and in it gritty bits of teeth. And her jaw, it felt like the marrow in the bone had been

replaced with broken glass.

And what was this thing she was lying in? With the bars on it she thought it was a birdcage. Yes, the man~human that lived in the box~on~wheels had just such a cage, with a bright yellow bird in it that sang loudly and sometimes all day long. Once, her brother Reould crept over to the cage to see how loud the bird would sing from "inside my stomach", but all he got was hit over the head with a broom and angry human words yelled at him as he ran away. She couldn't help laughing a little on the inside when she thought of that, but even that hurt, rippling pain through her.

Now, as they journeyed on and on, the strange high~low dark~light hum of human voices cantered near her—the throbbing mass of her, breathing barely, drifted into a kind of

dream somewhere between full unconsciousness and waking. Images of her mother, Prilty, her family, the oak tree and the green field swirled in her—all these scenes pushing away pain to the edges of her, only then to have it ebb back over~turning peace.

At last the rolling stopped, and this time for a long time. She felt the cage lifted up and carried, then a cold, wet spongy thing full of salty water was put into her mouth and rubbed around her lips. The fresh wetness felt good but the salt now began to sting all through her mouth and down into her throat. Pain banged through her and she gave a big sigh and tasted again the blood in her breath. She felt lifted from the hard floor of the birdcage and put gently into a big box that had in it the warmest, plumpest bedding she had ever laid upon. The box closed up and light disappeared

and soon there was no noise at all but her heart's beat. Now sleep came quickly upon her and she fell into its soft, dark hands not knowing if she would ever wake.

Small holes of milk~colored light appeared along the rim of the top of the box and fell on her face, and she opened her eyes. Or did she wake? Surely she *was* awake—for surely no death could be still so painful so long after it had occurred. A brick~dry block of matter is what she felt like—that every tiny and large ache and thread of pain had woven, in the night, into a congealed, furry lump of evermore dense hurt.

She heard a door open and large amounts of light gushed into the room and the top of the box came open and there was the man. He spoke gentle but unknown words to her and pushed the top of a small bottle between her

lips and sore, broken gums. Liquid squeezed out and went through her like a sparkling stream, refreshing every part of her. It took away nausea and in moments seemed to soften hard pain. Then he closed the box and darkness returned and she slept again. Later he came back and gave her to drink, through a long needle-like thing, a delicious pink liquid, creamy and so good.

Soon, laying constantly in the aching dark, she began to lose all sense of time. She slept—she woke or was woken—she drank the sparkling water or delicious pink stuff—she slept again. She didn't know if it was day or night or how long she had lain there. She guessed she must be waking and sleeping on the same time-rhythms as the humuns as they cared for her, and she idly wondered whether she was becoming a

day~possum and would lose touch with her moon~child vibrations.

Then, something most strange occurred. They always talked in kindly tones to her, the man and the woman, as they tended her, but they were just a blur and their words mostly made no sense. Only by listening most carefully and repeating some words over and over to herself could she slowly get a sense of some of them. But something they began saying she could understand straight away—and she could not believe it! They were calling her by her name! "Drink, Harriet." "How're you feeling, Harriet?" How could they possibly know her name was Harriet? This was *truly* significant.

After a while she started to get taken out of the big room and into the "house", she guessed it was—when she was given the

liquids—and she became aware that there were others living there besides the man and the woman. There were birds, she could hear them singing and talking, and she saw a brown and black cat sitting upright and looking at her from a distance. Each time she saw the cat it was sitting upright and looking at her from a distance. And there was a black and white dog who was like a bulldog, only handsome. His name was Billy, but he was so boisterous, my goodness, when he met her he started jumping all round the box and she thought he would jump on her so she just had to try and bite him. This hurt her more than it hurt him but even so after that he more often looked at her from a distance, like the cat.

Now, it seemed scarcely possible to believe, but after several days and several nights more of mostly sleep and more

sparkling water and delicious pink stuff, and even a couple of times soft, soggy "cat-chow" type food, she was beginning to feel better—stronger—the pain was no longer in all of her. Her head still ached and her jaw hurt most of all still—it felt out of place or something, crooked or something, on the left side, and pretty much full of broken teeth, and she eased the pain of it by doing an extra big yawn every so often—she didn't know why that helped but it did. But she no longer felt nauseous or bloody inside, or near to death. Now they (the big man and the fair woman) took her, one twilight, out of the big room and put her box down in a garden—straightaway she could smell flowers and plants—her nose was working good in that respect. The man lifted her out and put her on grass. It felt

so wonderful to feel grass and earth again. She couldn't see much, her eyes were still foggy, but she walked slowly about—a small step at a time—and sniffed many plants—an aloe vera and a cactus and a jade tree and a beautiful blurry pink and white rose. And then, for the first time since she couldn't remember when, she had a sudden urge to "leave the room" as it were, and to her great satisfaction everything worked perfectly! This was a good day.

The following twilight she began again to groom herself as had always been her habit on waking. She must have looked a sight all these injured days, her matted, bloodied and frazzled fur and bent whiskers. Her hands and feet, when wetted with a little saliva, were perfect combs for unmatting and glossing her white and inky

black coat and for smoothing and brushing her eyebrows, whiskers and face. She took great pride in this.

As more days went by and she was lifted out of her box for a few hours she began to discover more wondrous things about this place. At first all her steps were slow but after a while she tried a scuttle, and then loped a little in her characteristic way, and once, feeling a spray of rain (or was it a garden hose?), she even ran—a kind of speeded-up lope. The man and woman seemed to find this amusing. She never thought her running-style was something to cause laughter—she'd seen humans run and that was funny! In her still "foggy-eyed" state she bumped into a magical thing—the dark trunk of a huge tree, right in the middle of the garden. She felt tired even thinking

about climbing it at this stage—so high into the sky did it's bright, hazy forest of red and gold leaves seem to reach. Up the pathway, away from the garden, were more treasures. A stairway made of wood and iron went up to the landing where the front door of the house was. This she discovered by climbing it—one slow step at a time. How many steps? She could only count to "five" and as she went she counted "five" twice, and then "four" and she was at the top. She didn't know what number that was so she made it 554 steps. That seemed a lot, but the climbing was very good exercise for her.

Across the pathway were more trees. Three cypresses nearly as high as the stairs grew along the wall there. It seemed their foliage was all woven together and would make an excellent place for nests, but she

couldn't climb them yet—unlike the stairs they were straight up. She wasn't the greatest tree-climber at the best of times she knew that. It wasn't so much the climbing-up as the climbing-down. She would always get to that point where the branches weren't low enough to the ground for her to wrap her tail around and stretch herself down to the bottom—she would always just "let go" and land, sometimes on her hands—but more often on her head! She had heard how it was best to dig your nails into the trunk or stretch one's tail around the trunk and she wanted to work on that.

A few steps from the bottom of the stairs she discovered a front fence and a gate, all made of those straight, black iron bars. Now, all the other walls around the place were high stone ones that none could climb, but this

was only half as tall as a tall human. She didn't really want to get out of this place—not yet—she didn't know at all where she was, but when a possum sees an iron gate she, or he, must try to climb it. This would be one of her first straight-up climbing challenges in a few days.

And there was something else about the bars. They were great for chomping on, for strengthening and mending her jaw. She guessed it had been broken on the left side, although she had broken her right-side fang—she couldn't figure that—and it was still not fully fixed. But she found if she chose a particular bar, opened her mouth as wide as she could—which was really wide—and "chomped" on the bar and chewed it and ground it, it began to make the jaw feel better and stronger. However, the humans from

the house next door who had come to watch her in the garden, when they saw her do this, looked terrified, picked up their little ones and ran away. She didn't see them again.

She was soon feeling so good she would not wait if the man and the woman were at all late in taking her out to the garden. As soon as the moon began to glimmer, whether she could see it or not she could *feel* it, and she would stick her nose into an air-hole, bite it bigger and "bust" right out of the box. But this was, most often, not a solution. For if she was in a locked-up room of the house all she could do was sit on an armchair till they came in to get her. Very soon the box of cardboard that had been her refuge and nest before she "shredded" it was replaced with a new, big blue one with a wire gate and made of some stuff she couldn't bite through or nose

through—ever!

She climbed the cypress trees—grip/ hoist —grip/hoist—grip/hoist and found them full of dark tunnels of foliage she could hide and snooze in. And she climbed the iron gate a couple of times but that made the man and the woman upset and she got yelled at so she decided to stop and just use the gate for chomping. There wasn't much out there, anyway. She met a grumpy cat and there was a long, concrete driveway and at the end of it a horrible black strip! She much preferred this side of the fence.

And soon she was up for climbing the wonderful tree of colors. It's trunk, before the spread of branches, was twice as tall as the cypress~tree trunks and three times as thick around. Its gold~brown, red~blue haze of leaves seemed to fill the sky as she gazed

upwards from the base. She got half-way up and tore a fingernail, but with granite determination she forged on and made it all the way up the bare trunk—after that it was a breeze to clamber on through the beautiful branches. It was an ornamental pear tree! One thing she was really good at was identifying trees. She knew them all—this one would have leaves and blossoms, but no fruit. She climbed up—way on up and espied a grand panorama of houses, gardens, trees— and in some of the gardens there were dogs, big wild-looking dogs. All well beyond the stone walls that none could climb!

And as she lolled in the topmost branches amongst the raffling, many-colored leaves, and felt the fading warm of twilight and had not the mildest touch of injury or pain in her, she wondered whether or not

she had in fact landed, after all her grief, in a little piece of possum heaven.

A few days later, the day after she had felt the first cold of winter come snipping in the wind, in the afternoon as she slept in her blue box, she woke slightly to feel the box being carried from the house, and down the stairs and through the gate—and then she felt she might be in the car, but she wasn't sure and dozed off again. She woke more fully some time later to realize she was, in fact, in the car. The man was in it too, and they must have gone a long way. Where were they going? Were they going for more of the delicious pink liquid? That was the only other time she had been in the car since it had carried her home that terrible night. But that was only a short time—this seemed much longer, and she peered out of the air

holes of the box trying to see the world racing by beyond the glass.

They went a long way further, and on some rough parts, and finally they came to a stop in a place like a forest clearing. A round man was there and a woman in front of a yellow house. The man talked with them, then he lifted her blue box out of the car and, carrying her, walked with the round man up a sloping verge and through a gate in a tall wire fence. She peered out intently as the box bobbled up a stony pathway past cages and boxes with what seemed like many strange creatures in them—and then suddenly *she* was in a cage, in her blue box—on a ledge in a cage that was not much bigger than the box itself, and with a dead tree-branch stuck in the middle of it! "Bye, Harriet," the man said and he spoke again to the round

man and they walked away down the stony path. "Bye Harriet"! What did he mean by that? She watched them until they were lost from her sight.

What was this place?! There were gigantic, grey cats and gigantic birds with claws like big knives—in cages and wooden boxes right near her! Just a few bounds and skips away. She called them "cats" only because they looked like cats she'd seen but only so much bigger that they were surely monsters of some kind. And there was one, not as big as the grey ones, that had a coat like the leaves in the "change-of-colors" time—not that that was around here for all the forest trees were green or without leaves at all. And in a cage further up the hill there was something that seemed like a white dog that was bigger than four normal dogs. Some

of the big birds were screeching loud and it was feeling so cold. Suddenly, the round man appeared and put some woolen rags into her box and on the ledge. But where was *he* who had brought her here?

She lay there waiting all through the gloomy forest of the afternoon but he didn't return and didn't return and as the darkening night descended, the horrible truth descended also. She had been abandoned to this place—she had been given away! She was no longer "Harriet who had been saved" but a caged beast in this loud and frightening wood.

Food was there but she didn't want to eat, and a blanket on the ledge because it was so cold and she might otherwise have slept through all of such a cold night, but she couldn't sleep—and the hissing and growls seemed all around her and high

whining sounds, would they never cease?

And then it seemed one of the giant cats was out and was right in front of her cage! She could feel it's moist breath. She jumped in hot fright so wildly that the box toppled off its ledge and rested against the tree-branch and she awoke and realized that that horror at least, was just a nightmare. So she *had* slept, if only for moments, and briefly she held her breath to wonder if all the rest of this day might be a nightmare too. But no. The sharp, frozen moonlight full of alien sound, shadows of forest across hulking cages, shuffling, disturbed footfalls, and on every chill wisp of wind, scents and smells she had never known before.

As the white day broke and still no sleep had come, there was at least a quietness over the place, for sleep had come to others if not

to her. She lay there staring out at the strange terrain. A sloping hillside full of trees and with many cages piled around and through them, clearing to the stony pathway near where she was.

She had been through so much, and they had been so kind, the man and the woman, and she was really beginning to love being there. With the stairway to climb and her very own beautiful pear tree—and Billy and Annie, the cat, who was about her size and was a cat she even thought she could play with at some stage—if only she would become less distant. And that Billy, she thought his eyes were so bright and full of feeling they could be possum eyes. She hadn't meant to "snap" at him that day they first met, she was just frightened by his jumping all around her. She didn't know if that was

the reason they had got rid of her—perhaps she had been just too much trouble to look after, or maybe they just helped her get well and that was it. Whatever the reason, as she thought of all these things and of her mother and Prilty even further away, the rims of her eyes started to get wet and a big, salty drop of tear squeezed out and fell down her face.

The following night was bitter cold again, but she managed to sleep a little after crawling —you couldn't call it climbing—around her cramped cage, and in the morning itchiness made her wake. She realized that a thick winter coat that she had been willing her body for since she got here was already beginning to grow.

Later that day the woman, who seemed to own the place and told the round man what to do, came and cutback an old mulberry

bush that was beside the cage on the upslope side. Harriet thought that was just great! Now she would have no shelter at all from the cold swirl of winds. But lo and behold, what did she see on the other side of the bush but another cage and in it were—possums! Three babies, they seemed like, only about four or five moons old. Well, she may have been lost and distressed and sad but now—at least—she would no longer be lonely. But to her dismay her friendly greetings were met with blank stares—then they began making faces at her and one threw a stone at her but it hit the bars of her cage! Some rude gestures and another stone followed soon after. She thought they were brats and decided to pay them no further attention. Still, she was reassured that if little horrors like that could survive in this place, then she

could too.

A cold night and a windy day later she was visited by the little kestrel again. He had visited her on the first afternoon but Harriet was so freaked out about being there she hadn't wanted to communicate with anyone, and ignored his hawky chatter. He seemed to be like a messenger and would fly at will to the different cages and return to his own big box, the gate of which was never closed. His name was Carlos, and in response to questions he told her that the enormous cats were "mountain-lines" and the big, white dog was called "a wolve." She had never heard of such things! Birds were very knowledgeable, Harriet found—Carlos nearly knew as much as Don. The cat who was the color of the leaves was called a "Karakal." Carlos didn't know if he changed

to green in the Spring, he doubted it but he promised he would keep his eyes on him and see. The birds were different hawks and owls but, unlike Carlos, they were always kept in their cages. Harriet had seen owls before. She and Prilty had met one one night when they were slug-hunting, but he was unsociable and gruff—and also he was nowhere near as big as these ones. Carlos also told her, not in response to a question, but that the three baby possums were orphans—that their mother had been killed by a human "hunter" and some other human had found them in the mother's pouch and had brought them to the park when they were no bigger than plums. He told her that this place was for injured or orphaned "native animals", or for those who had been pets. This last phrase struck Harriet deeply. So it was true. That that she had feared.

Soon Carlos departed, and when he had gone she thought again of the babies and determined to not turn away from them but to show care for them in their suffering, even if their behavior had been brattish. For, even if they no longer wanted her, had not the kindness and love the man and the fair woman shown her helped her recover from her terrible accident? It had, and she would always be grateful to them for that.

Yes! She would teach the babies all the things that their mother would have taught them, but could not. What trees were good—for sleeping in, for gnawing—and what trees were bad—how to make a warm nest on a cold day—how to climb on power-lines and not get "blasted"—grooming: how it was necessary to always look your best—how to learn many things about each day by

listening to the Earth spin and by the taste of the rain. Some things were harder to teach than others, but she would teach them all—and more. The thought surged within her! This would be how she would live. Caring for those afflicted as she had been cared for—binding their wounds and putting soft salve on their spirits as well as on their bleeding, and perhaps in this way she would not remember, so often, that she had not been wanted as a pet.

It wasn't easy getting their attention again. She persisted though—staring, smiling, even a small wave. Finally, dark mutterings started coming from their direction—a stone "bangled" against her cage and then the "faces" began again. This time she was ready and came back at them with the wildest, weirdest face she could possibly contort. Her eyes

"bulged" and became crossed, her teeth bared in a fiendish open-mouthed smile, her tongue bobbled back and forth and her ears "waggled" like crazy things. The three were astounded. They stared at her for a long time. Then the two bigger ones made some half-hearted faces back at her and tried to outlast her—but their spirits were no longer in it and they faded whilst Harriet kept her concentration, and her "face", for so long she began to wonder if it would go back to normal afterwards.

Henceforth they ignored her completely. Not one stone clattered against her cage, not one face was made nor word, however crude, was uttered again. This was a great disappointment to her—how could she help them now? She decided she would lecture them—daily, nightly, at all times,

whether they were out of sight in their box or snoozing on a branch or standing, or sitting, with their backs towards her—doing whatever. It was *not* rewarding work and after several nights and days of it she felt she might quit.

Then, she began to notice some small changes. The back of a possum-head she had stared at for hours, suddenly, slightly cocked, as though it's owner was listening —at another time a possum-body moving, ever so slightly, backwards to the side of the cage nearest her, as though to hear better. She was greatly heartened by these and gave forth with renewed vigor. In fact, on a morning not long after, the smallest one, who should have been asleep and whose name she thought was Briochte, came right up to the cage-side and said he had a

question. Firstly though he had to tell her, on behalf of himself and his two brothers, how thankful they were for all her teaching—they all felt sure they could go out into the wild world more brave and confident. Harriet felt joyful, and then came the question: "Can you piss and rub your stomach at the same time?" A great guffaw of possum laughter came from the sleeping-box—she stared into Briochte's eyes, there was no laughter in them—just innocent questioning.

All of a sudden the human woman was opening the door of her cage. "Come on, Harriet," she said in a tired voice, and lifted her back into her blue box. Harriet's eyes returned to Briochte—she felt—she hoped—his question was a sincere one which deserved reply—but what was happening? The blue box's gate was closed

and the woman lifted it out of the cage and began to carry her away! Briochte gripped the wire of his cage and stared mournfully after her, and as his tiny form receded she saw the other two come tumbling into sight and gather beside him—they were laughing and gesturing at her. One of them said, screeching: "Hey! Look at me! I'm listening to the Earth spin!"

They were gone from her sight, and she was "bobbling" down through the park past all the cages along the pathway—and then she heard a door open and the blue box was placed in the back seat of yet another car. The woman got in the front and the thing roared away. Oh, where was she going now? She hated all this moving around. Maybe she shouldn't have kept that "wild face" she made for so

long—maybe the humans saw it and thought she was looney. The woman played loud creature-scaring music as they bumped along and put her hand to her ear and talked to other humans who weren't there. The car went up and down and up and down bumpy hills and around sliding corners. She began to feel sick and the scary loud music continued. Anxious feelings clawed at her and made her thick with tiredness. Was she to be forever homeless and unwanted? The journey, as they went along, seemed further than the one that had brought her here.

Finally, after a long time, the car stopped and when it went quiet the music went quiet also. The woman got out and then Harriet felt the box being moved, then carried. She didn't want to look; she heard a gate open and close—clang! She

heard human voices—the woman and a man but couldn't understand them. She opened her eyes—there was a black door, and a landing. She was on the landing! "Welcome back, Harriet!" said the man. She was back home!! "Welcome home, Harriet!" She beamed. A big, eyes gleaming~eyebrow quivering~whisker smiling beam! They patted and fussed over her; even Annie sat watching her from a little closer distance than before. She beamed—she couldn't help herself, but, then, in all other ways she decided to remain restrained. After all, she wasn't by nature given to excessive displays of emotion and she had suffered greatly, a harsh and troubling time, while they were "ovacees"—whatever that was. Nevertheless, when she finally fell asleep that day she slept the happiest sleep of her whole life, and

when she awoke she ran down the stairs and down the pathway and into the garden and there stood the pear tree in all it's moonlit glory! But it had no leaves—the colors had fallen away and just the stark sticks of winter were there. She climbed up, and lingered upon a middle couple of branches, letting joy~waves ripple through her.

Then, she was suddenly stricken with a terrible thought. What if all this was a nightmare~in~reverse, and she would wake and find herself still in that horrible place! But rain began to fall—it wasn't the cold rain like there, this was a warm rain from the south—the kind she loved to bathe in. And so for hours she lolled in it, letting the waters drizzle and drazzle and soak through her—washing away the Park's grime, grass grime, dust grime, grime~grime, oil grime from her coat—all away.

The man and the woman seemed upset that she was staying out in the wet for so long and they tried to coax her down—but she just "beamed" with that ball-bearing luster her eyes got in moonlight, even rainy moonlight, and they finally gave up and went back inside the house.

For many more hours she happily bathed and groomed herself until hair-thin streaks of light scratched the dark in the east and the rain faded to a mist and dripping branches.

Now her ink-black spray of tips were glossy, her thick undercoat was frosty white, and her tail was as white as a white whip. She had heard, somewhere, that the human name for a possum came from a native-human word meaning "white beast"—and looking at herself in the puddles of morning light, she could quite believe it!

Now, the days were slowly getting longer and more warm rains would come. She really wanted to spend time writing down the opening parts of her journal. Getting it from the mind to the paper, that was the tricky part—and not being able to hold a pencil didn't help much either.

She worried about her mother and Prilty. She just wished she could let them know she was well and everything was very fine. She had not been killed—she had been saved. She hoped they knew that somehow.

From atop her pear tree she had seen how much of the area around was not unfamiliar—same kinds of trees, weather, similar breezes as in "talookalake" and far to the east a similar foggy range of big hills. She wondered whether they were

even all still in the same valley—but such a huge one she had no idea where.

One day she even thought she saw Don flying high in the sky to the north. Eyesight wasn't her strongest sense, heaven knows, but Don had a very special flying-style on account of having two in-grown feathers on his left wing—it made his flight rather quite "loopy" compared to other doves. He called it his Rocket-Style, but she knew it was because of the feathers. If it was him and they could meet it would be wonderful, and he could carry back her glad news. She wondered if Prilty had a boyfriend now —probably more than one.

One night she had seen quite a handsome fellow on the stone fence. He had come from somewhere in the neighborhood, but he couldn't get down from the fence into

the garden so he went away. He left quite a nice scent on the evening breeze though. Perhaps he would visit again in the Spring. She still wasn't that interested in boys—only vaguely.

She wanted to spend more time in her beautiful garden, and high up in her wondrous pear tree, and under the water-color skies of morning, climb the stairs and snuggle into her very own blue box, and dream of good deeds to do and days to come.

But most of all she needed to "get down" the journal—inscribe it somehow! "The Journal of Harriet"—"Harriet's Journal," the journal of her life—which she knew, in so many ways, was only just beginning.

The End

Printed in the United States
By Bookmasters